MOSA

COLORING BOOK

DESIGNS WITH A SPLASH OF COLOR

JESSICA MAZURKIEWICZ

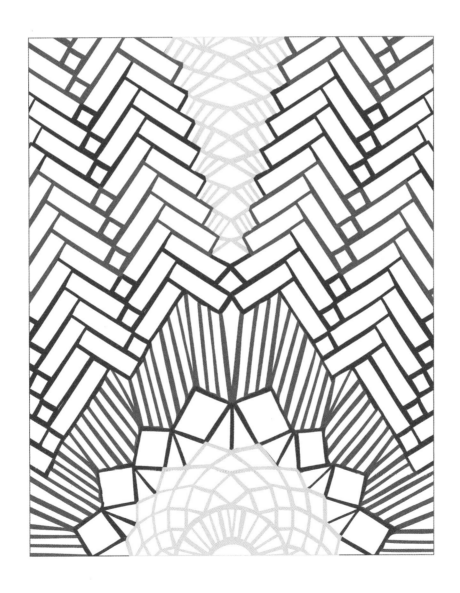

DOVER PUBLICATIONS, INC.
MINEOLA, NEW YORK

Traditionally, a mosaic is a work of art created from small pieces of colored glass, stone, beads, tiles, gemstones, or almost any other material. Usually integrated into walls and floors, the mosaic has been a popular aspect of interior design for centuries. In this latest edition to Dover's *Creative Haven* series for the experienced colorist, thirty-one mosaic patterns will delight artists and colorists of all ages. The versatile designs have been outlined in vivid hues, providing a unique opportunity for experimentation with different color combinations. Plus, the perforated pages make displaying finished work easy!

Copyright

Copyright © 2015 by Dover Publications, Inc.
All rights reserved.

Bibliographical Note

Mosaics Coloring Book: Designs with a Splash of Color, first published by Dover Publications, Inc., in 2015, contains all the plates from *Magnificent Mosaics,* originally published by Dover in 2009.

International Standard Book Number

ISBN-13: 978-0-486-80536-8
ISBN-10: 0-486-80536-0

Manufactured in the United States by Courier Corporation
80536001 2015
www.doverpublications.com

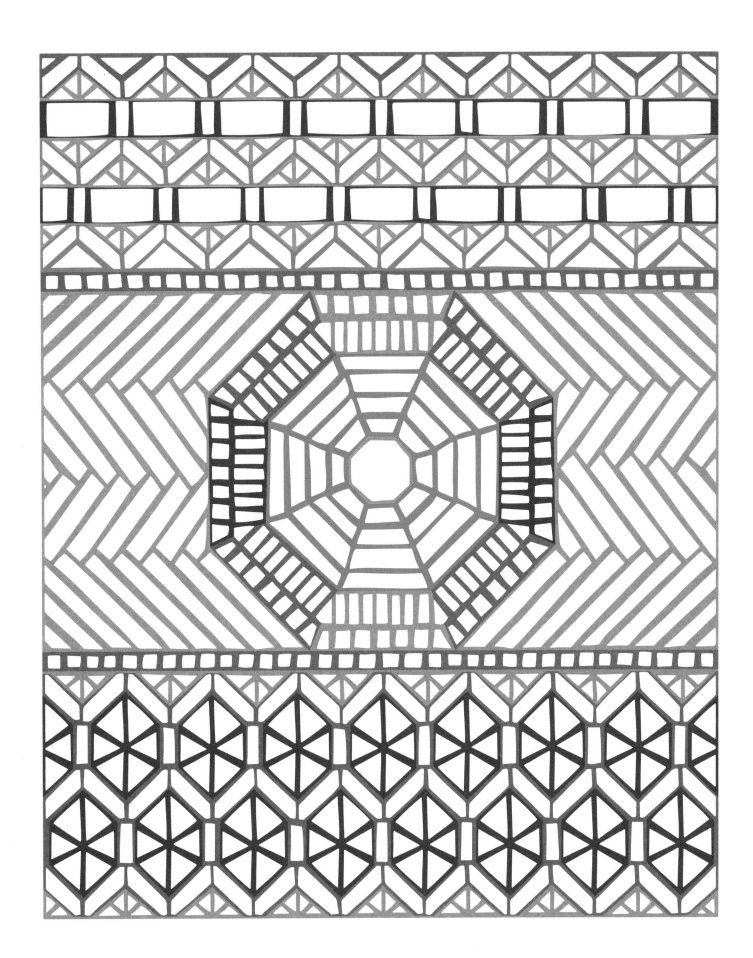

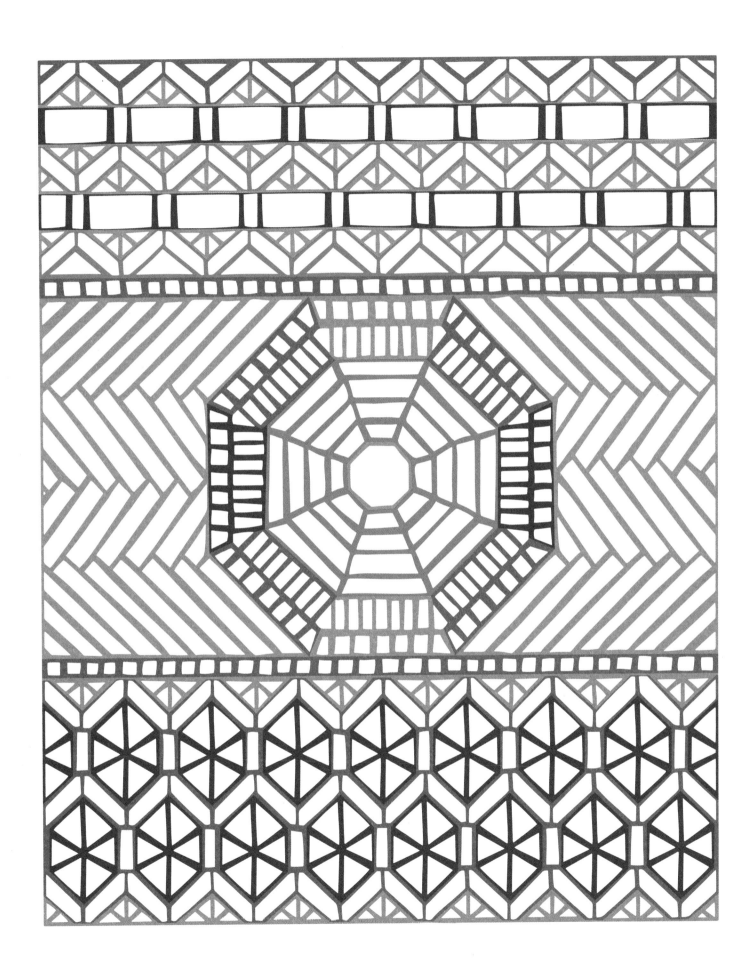

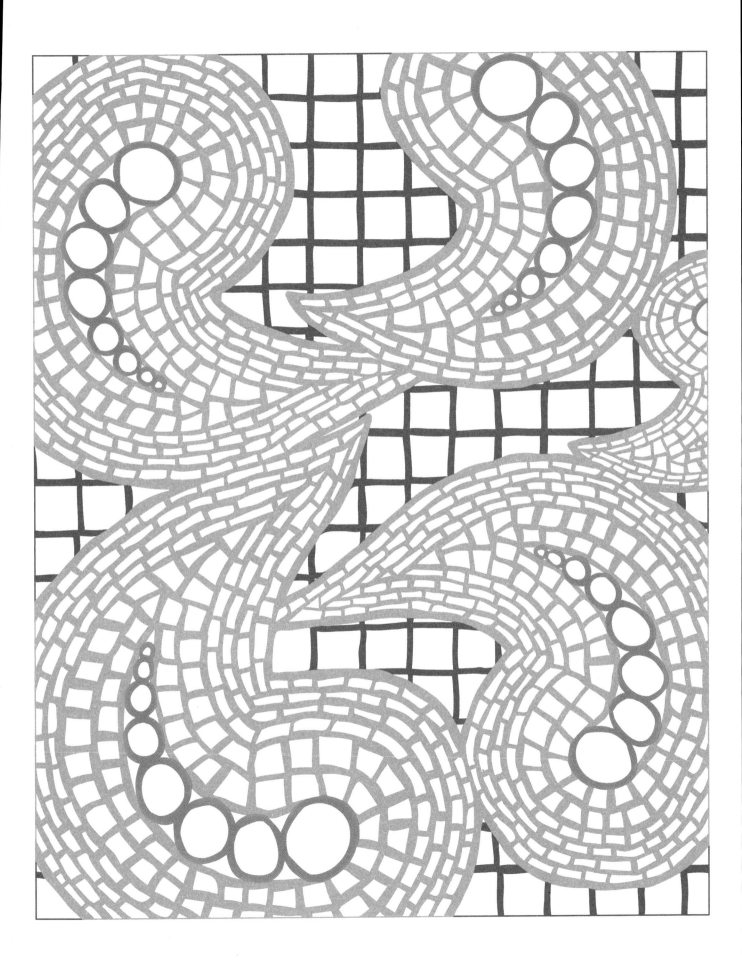

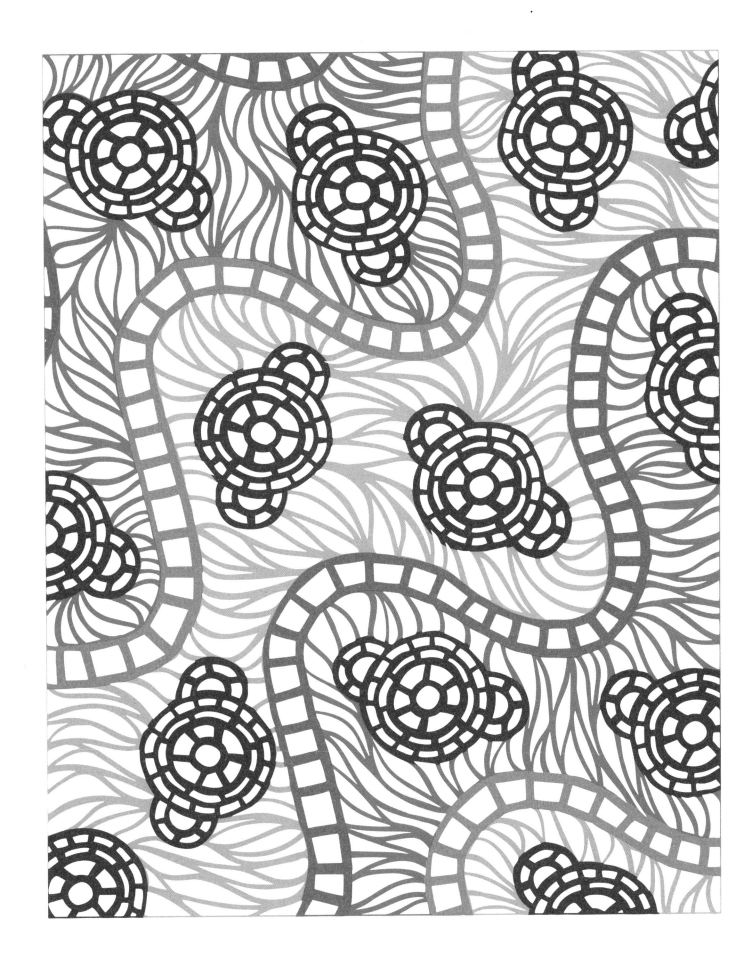

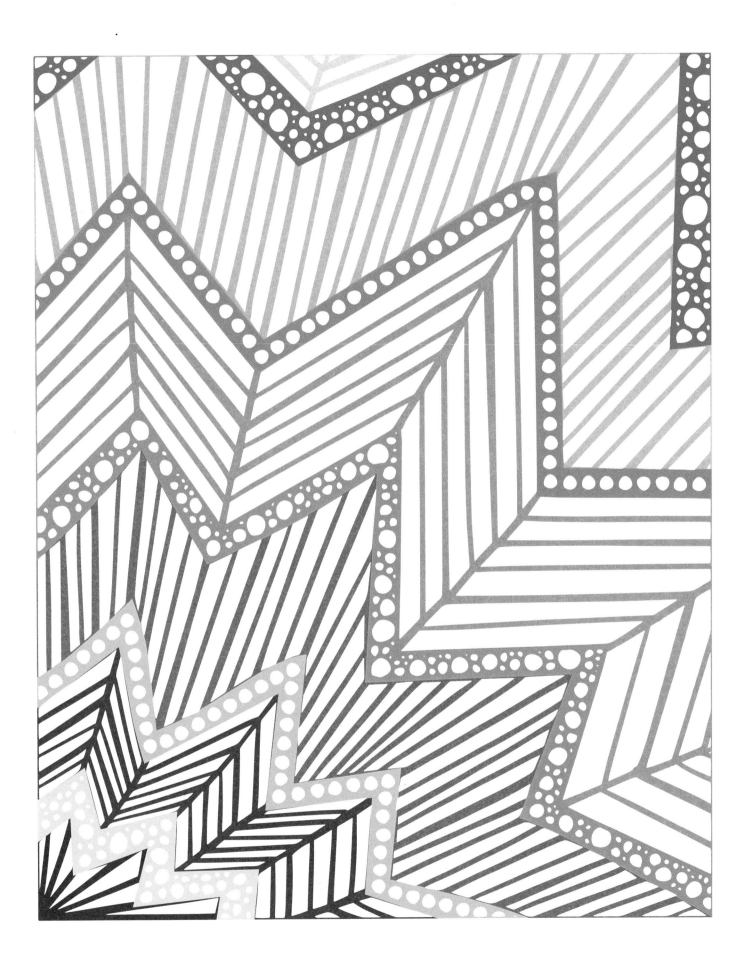

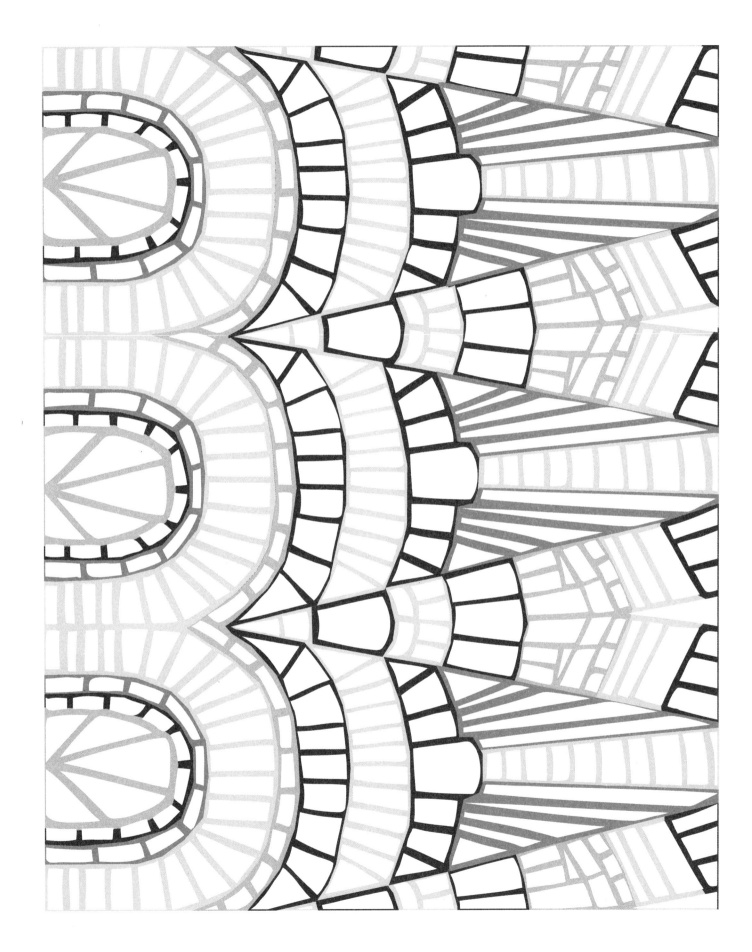

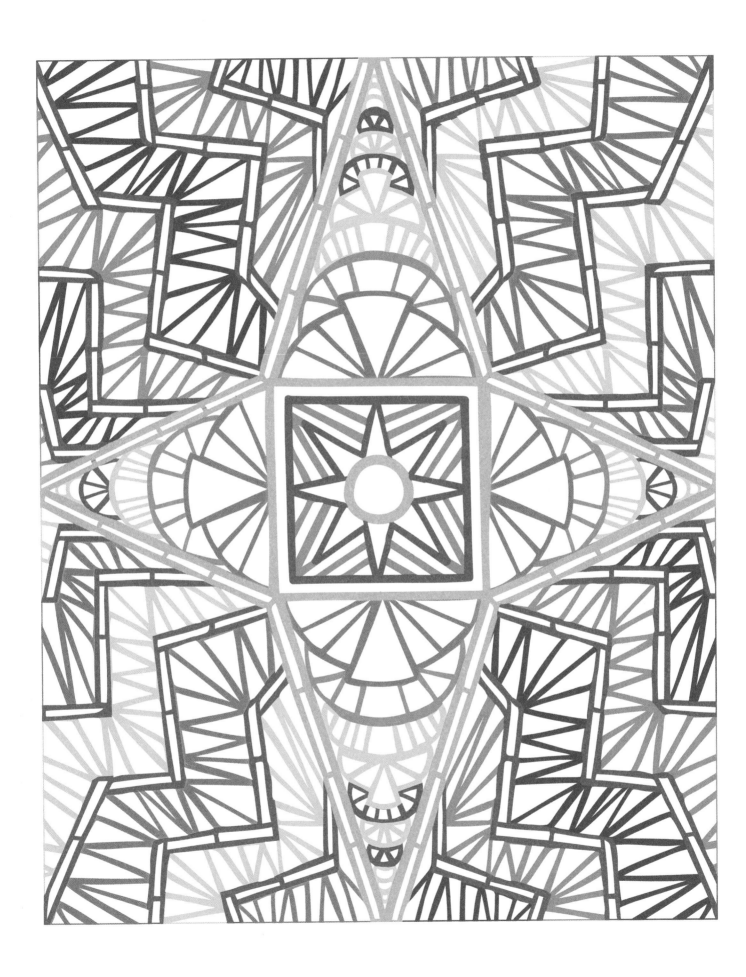

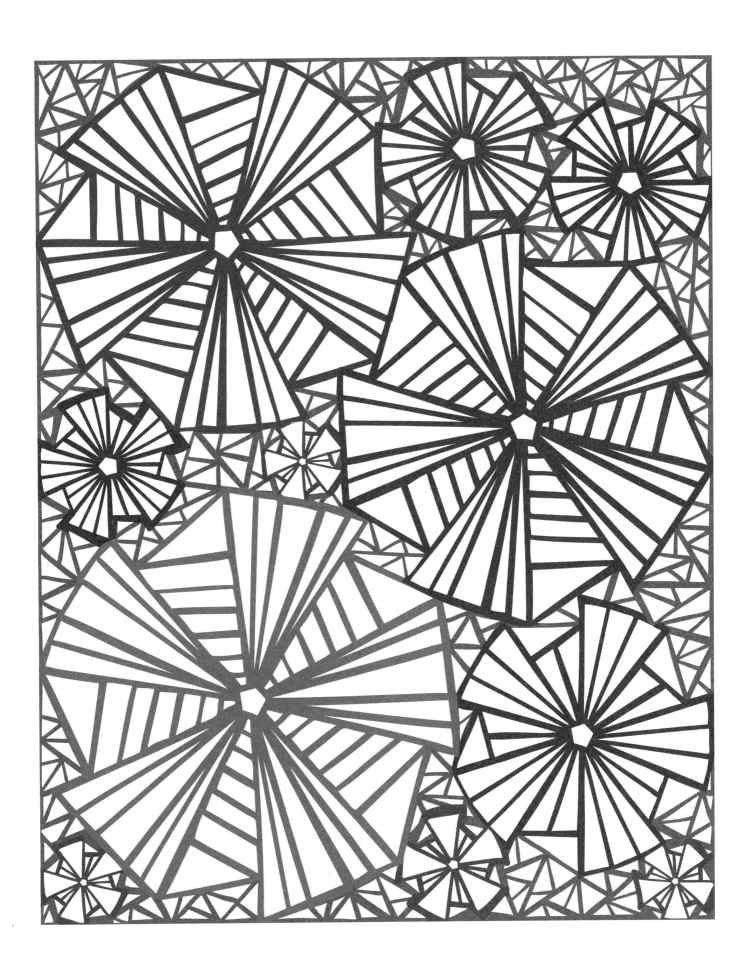

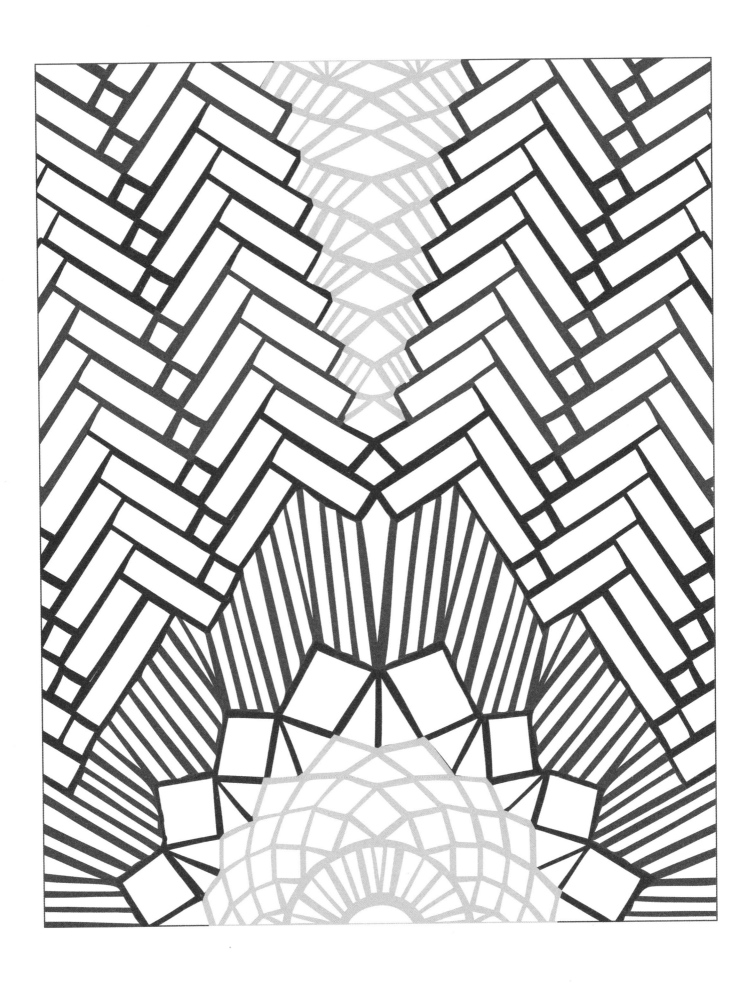

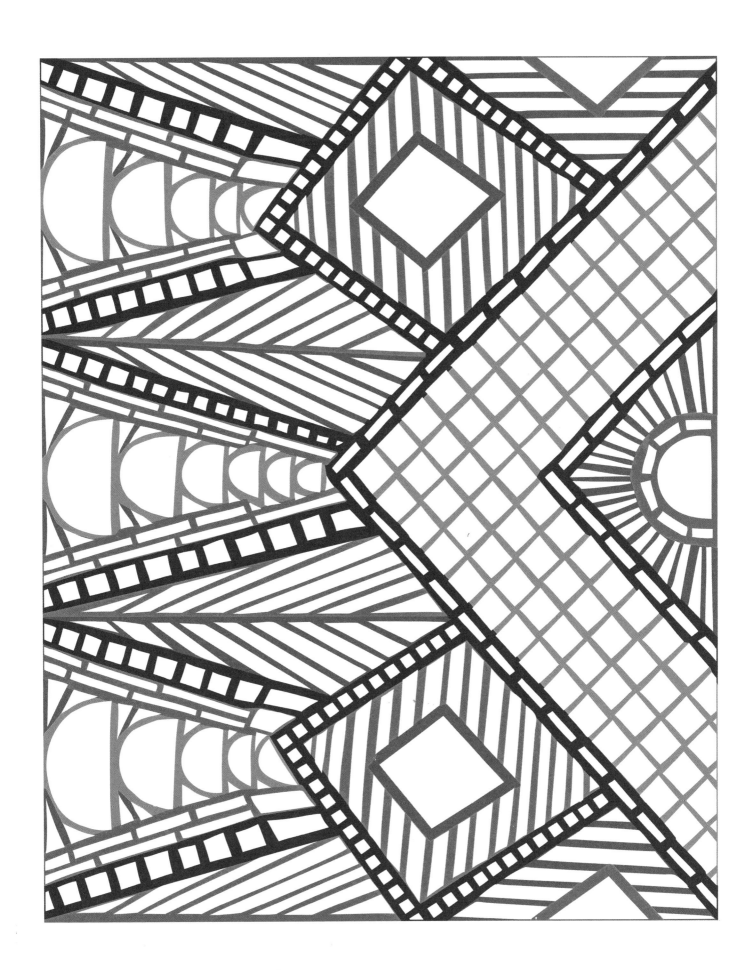

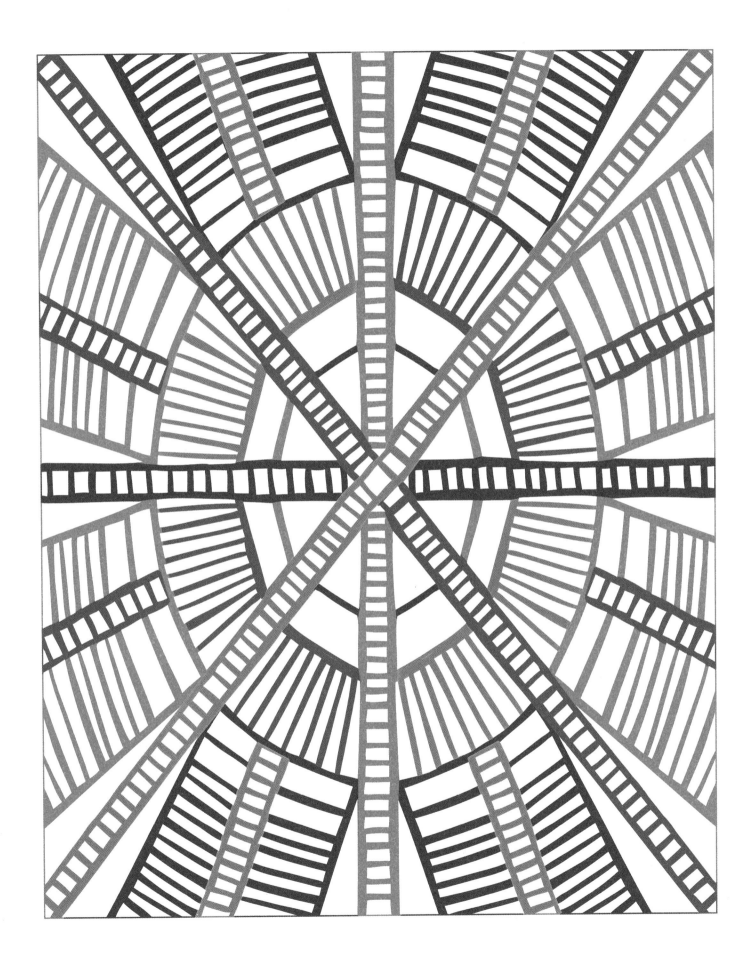

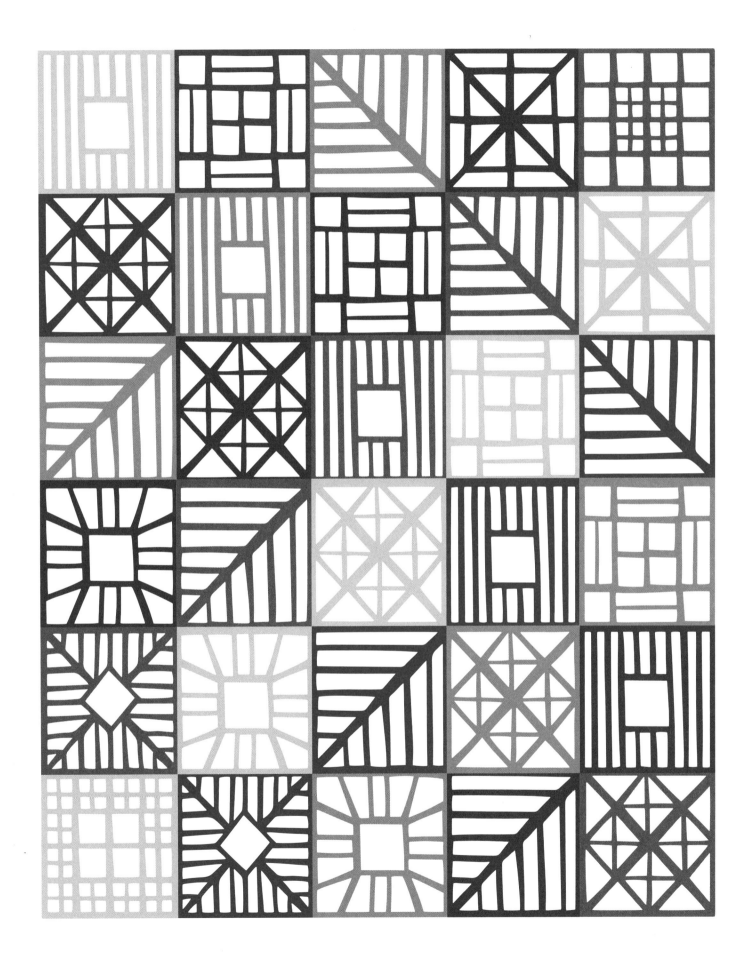

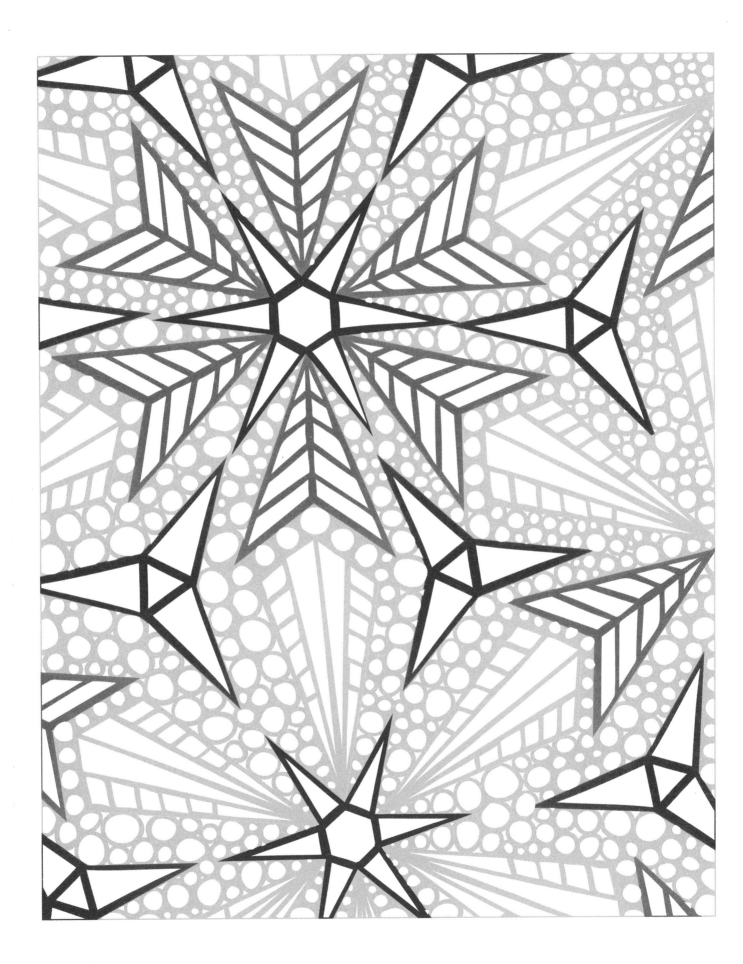

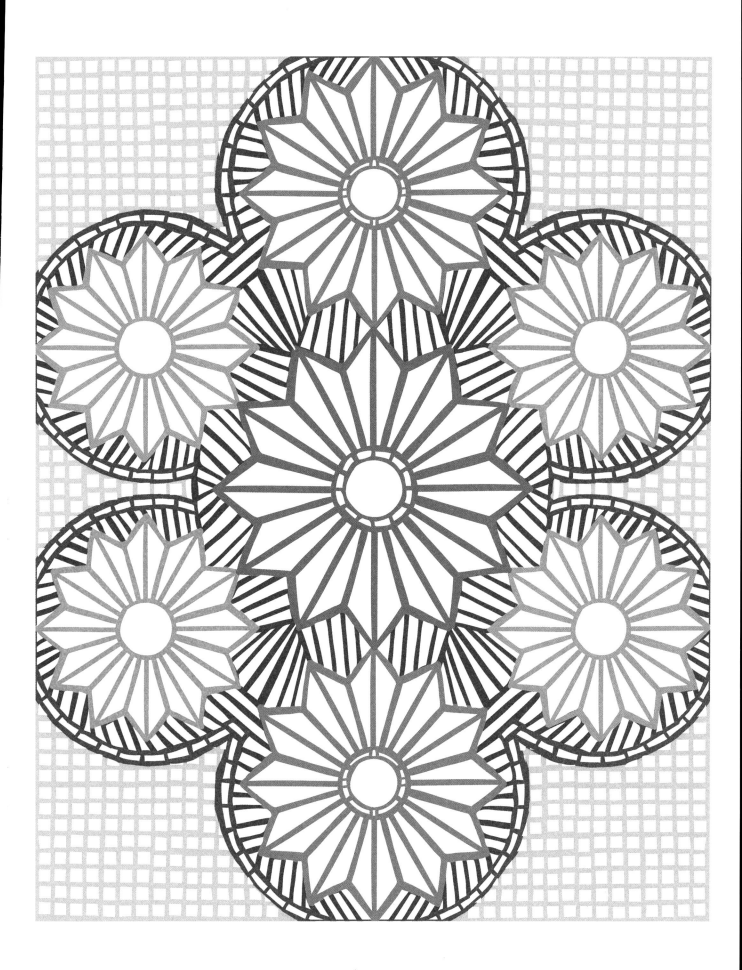

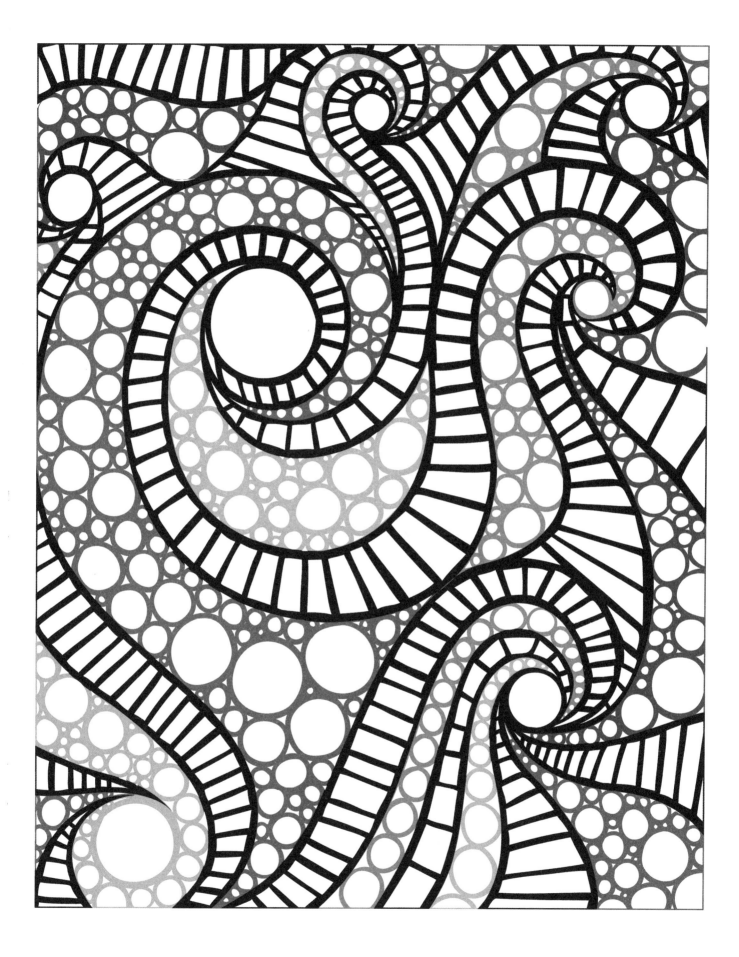

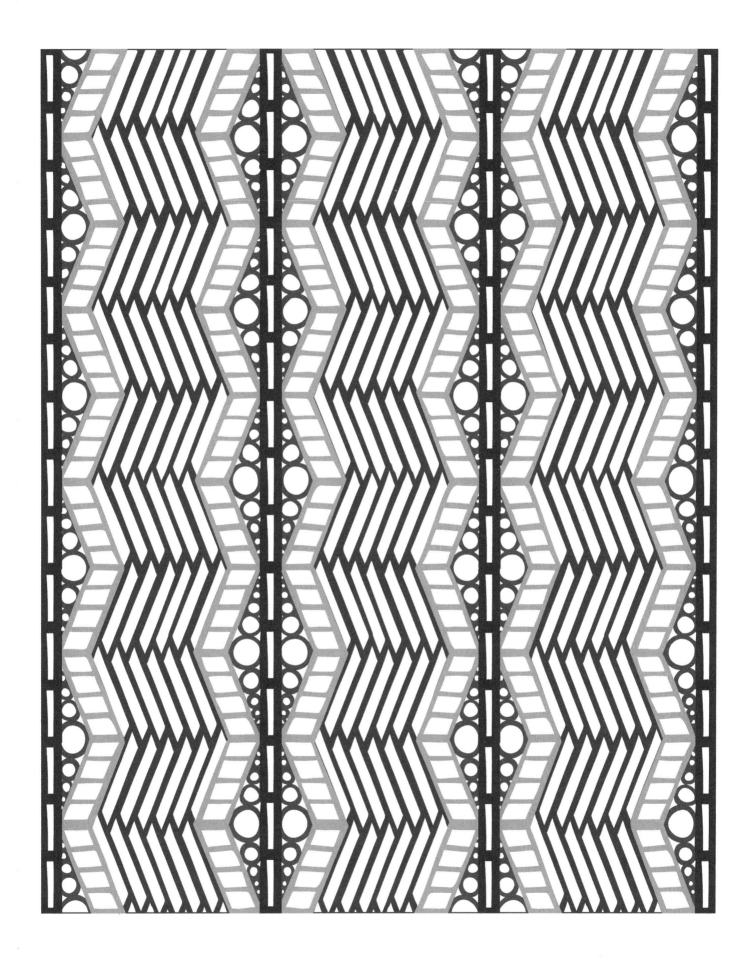

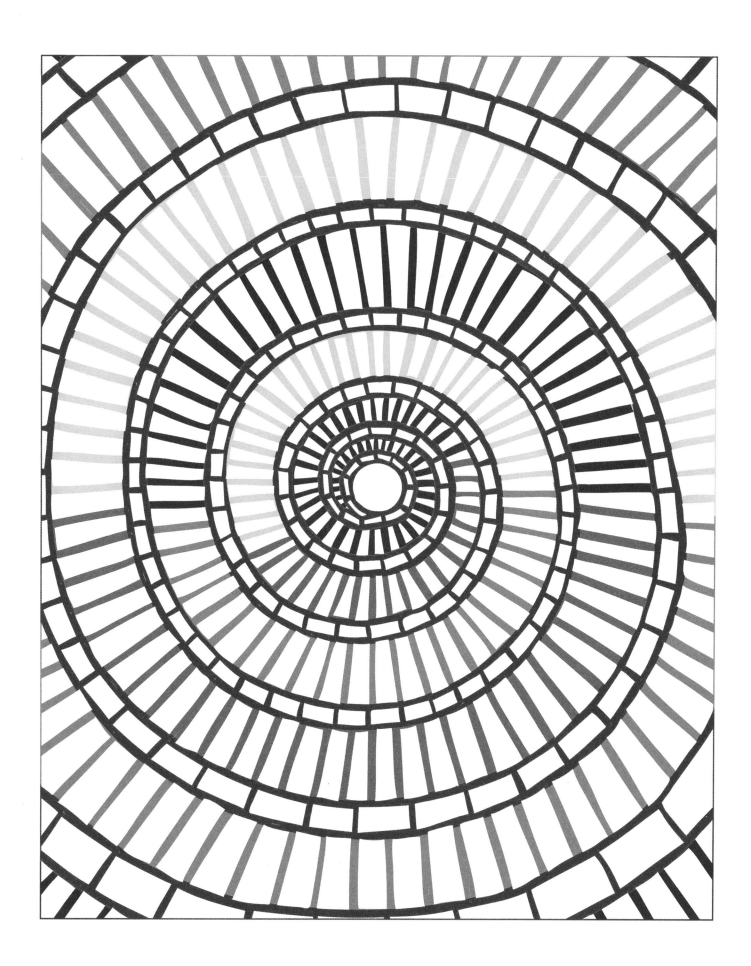

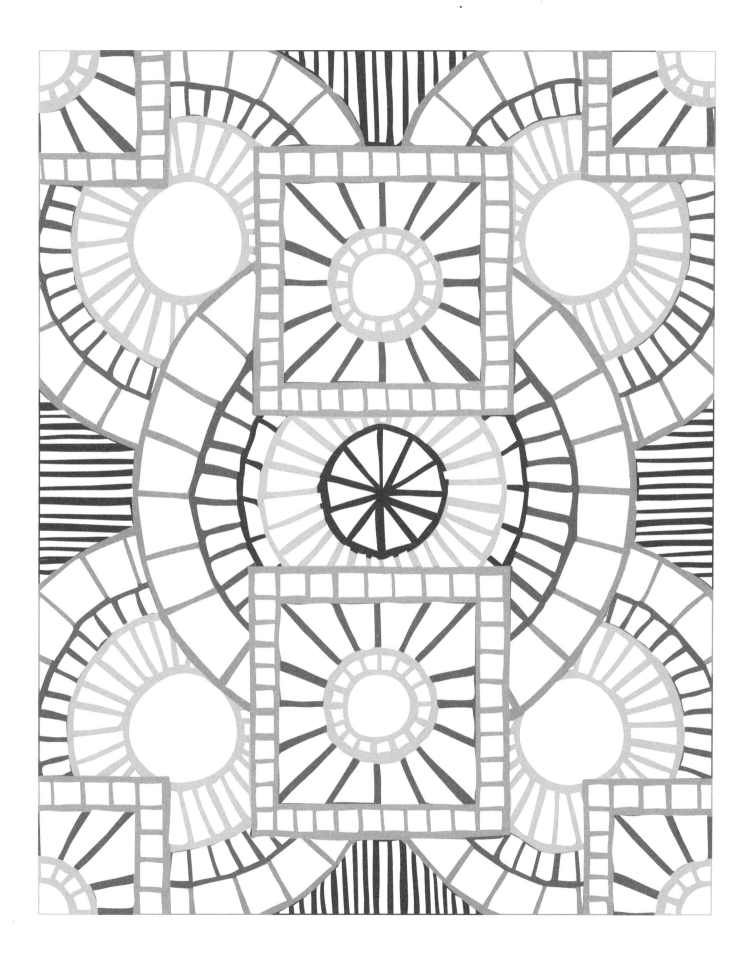

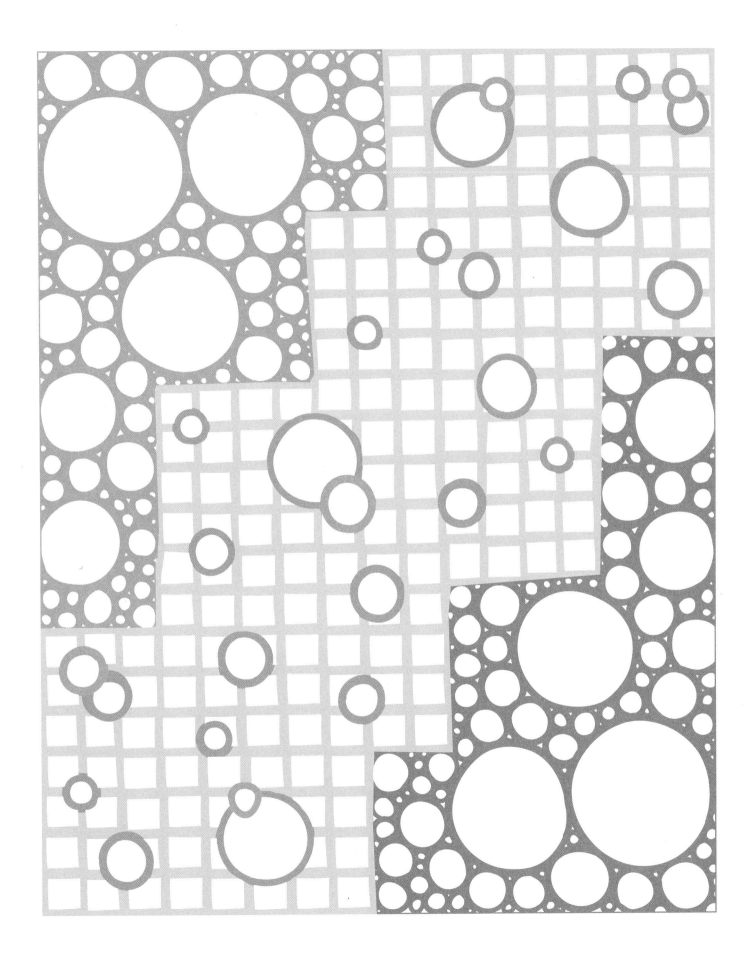

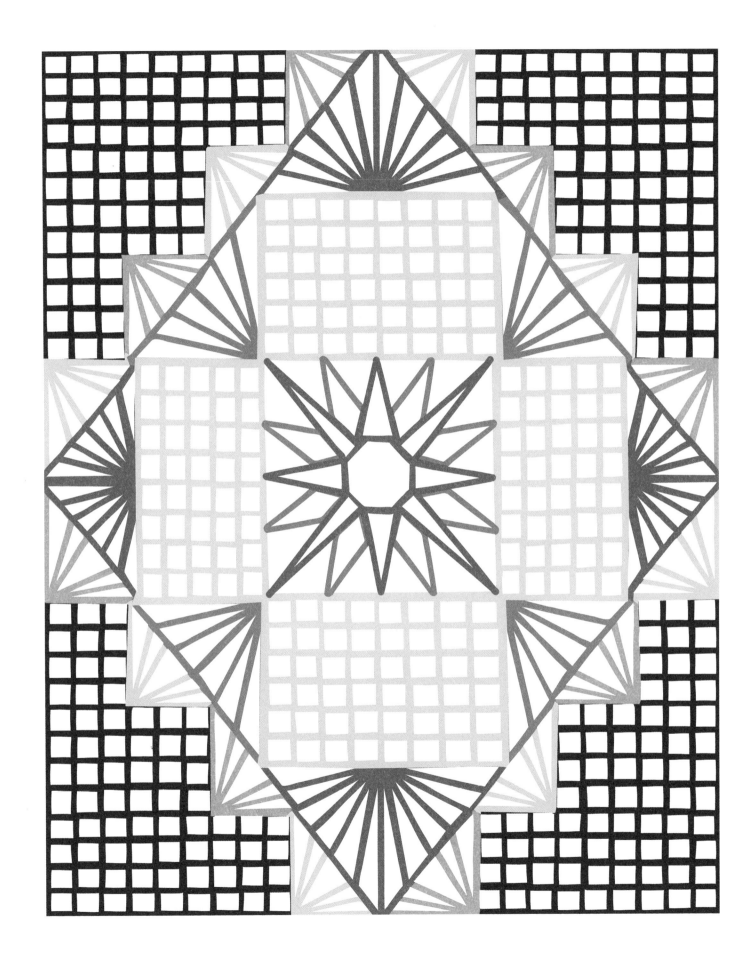

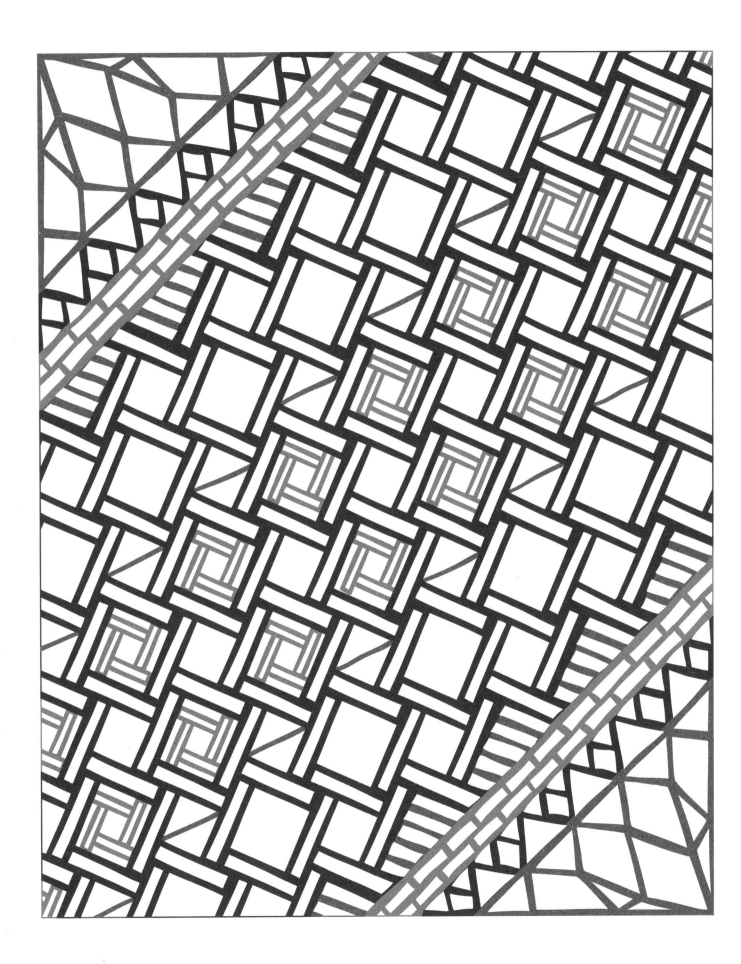

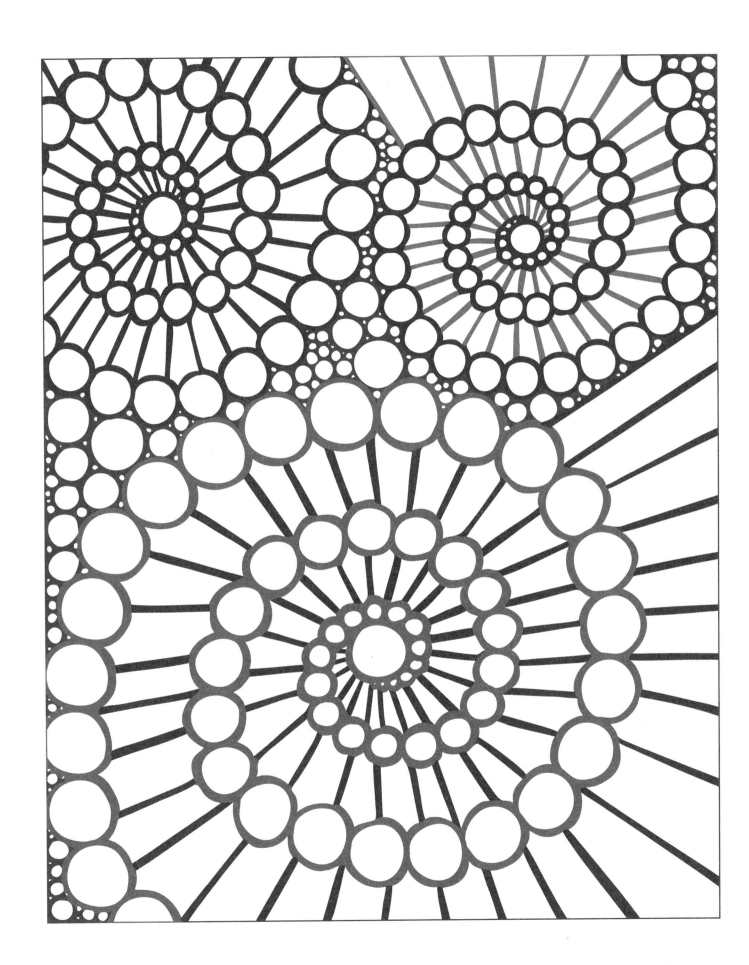

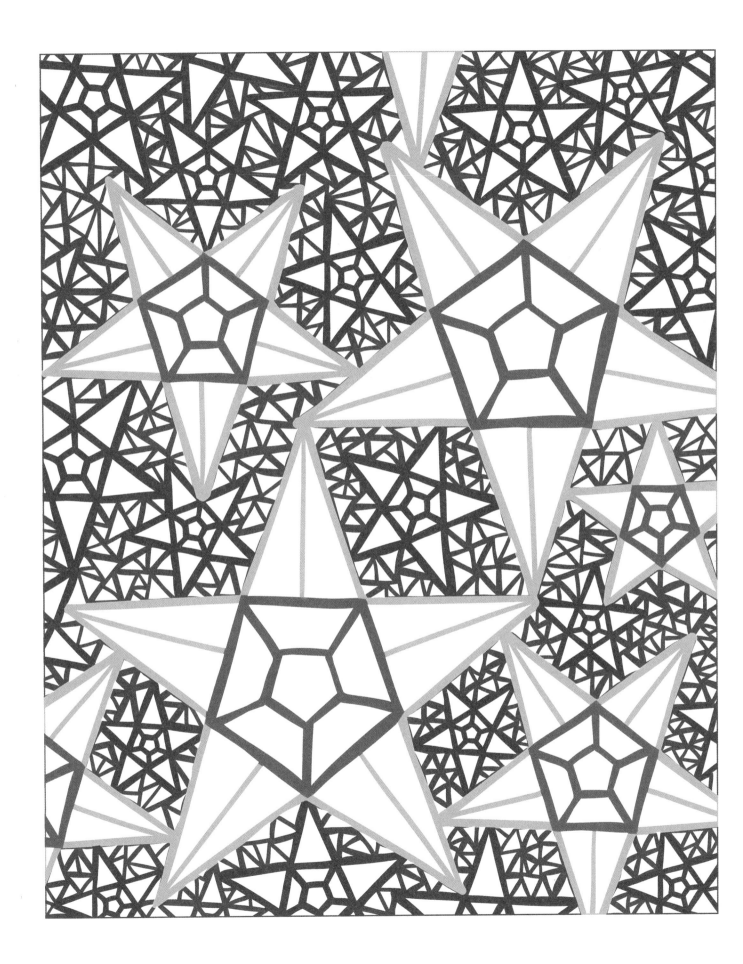

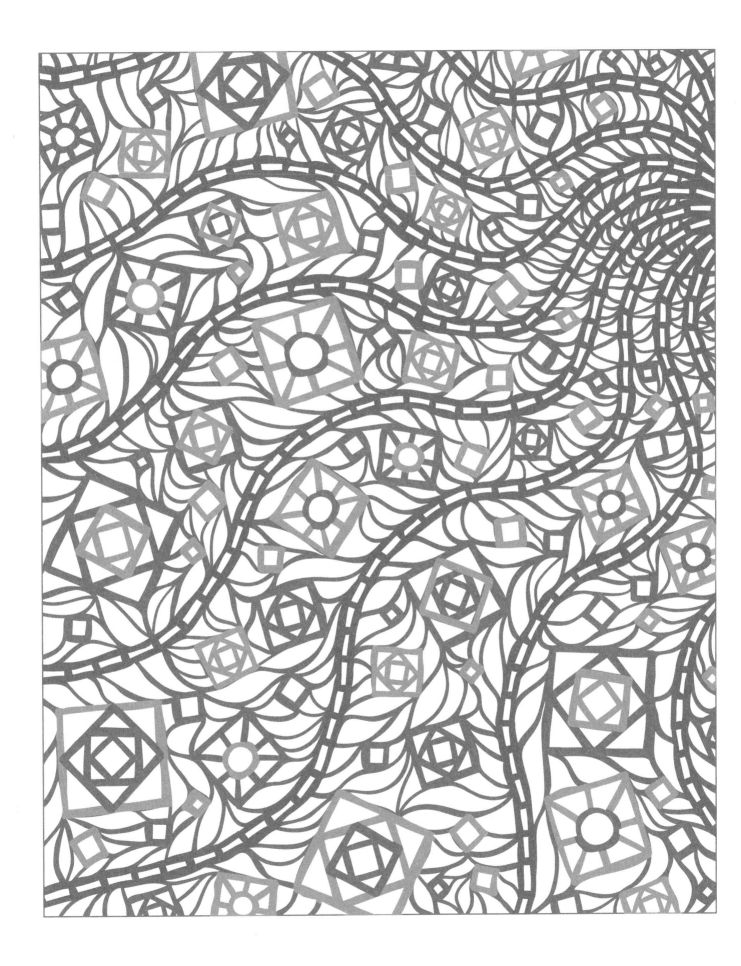

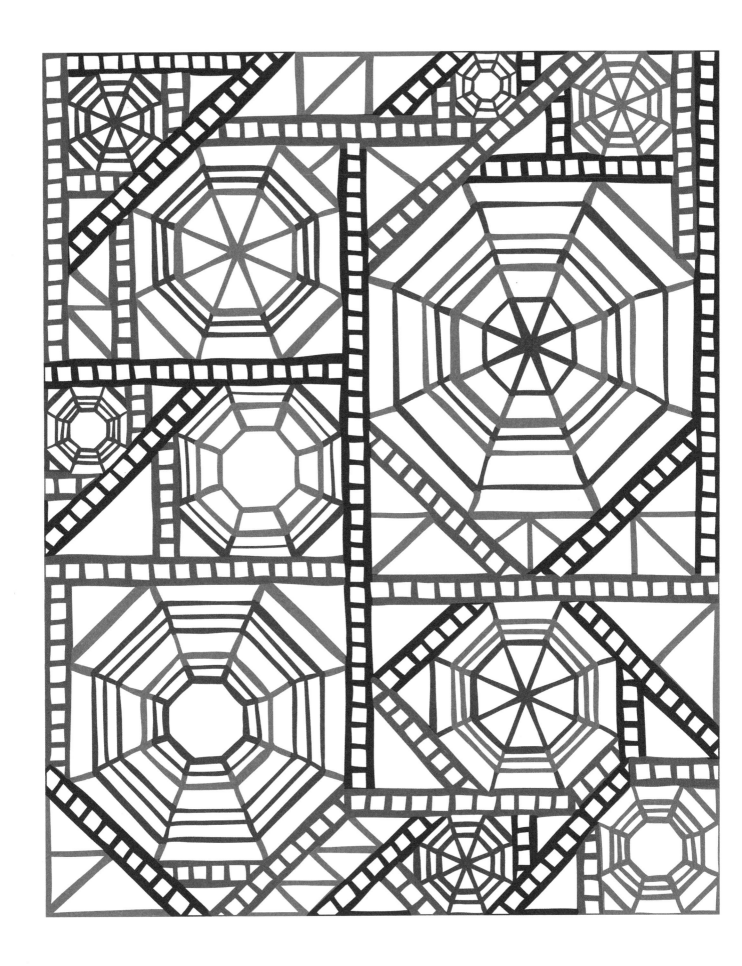

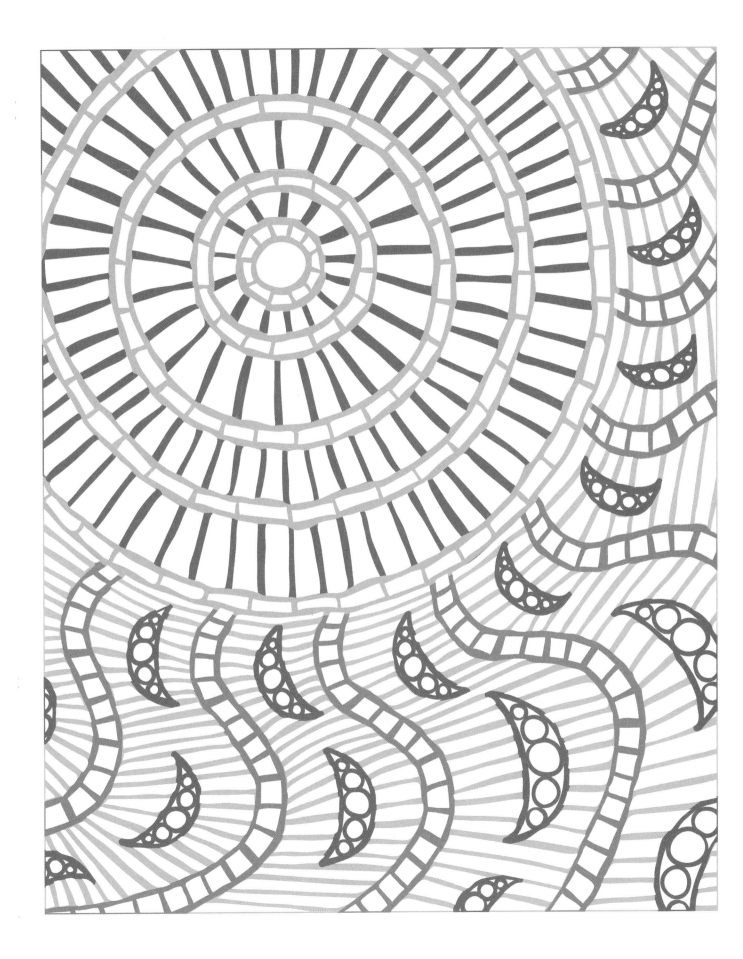

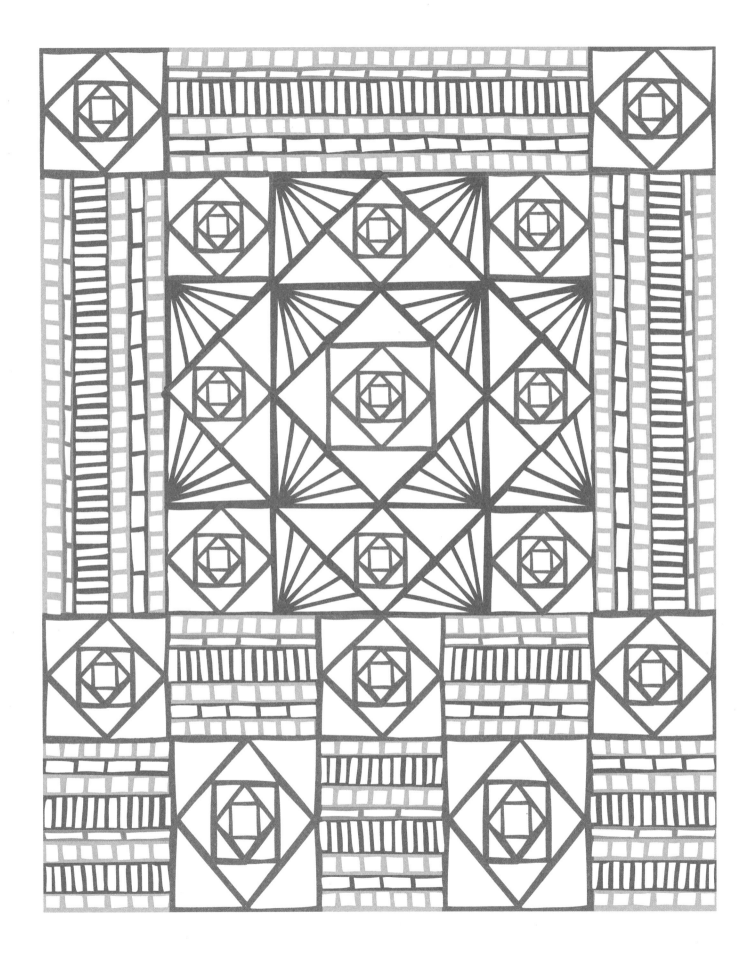

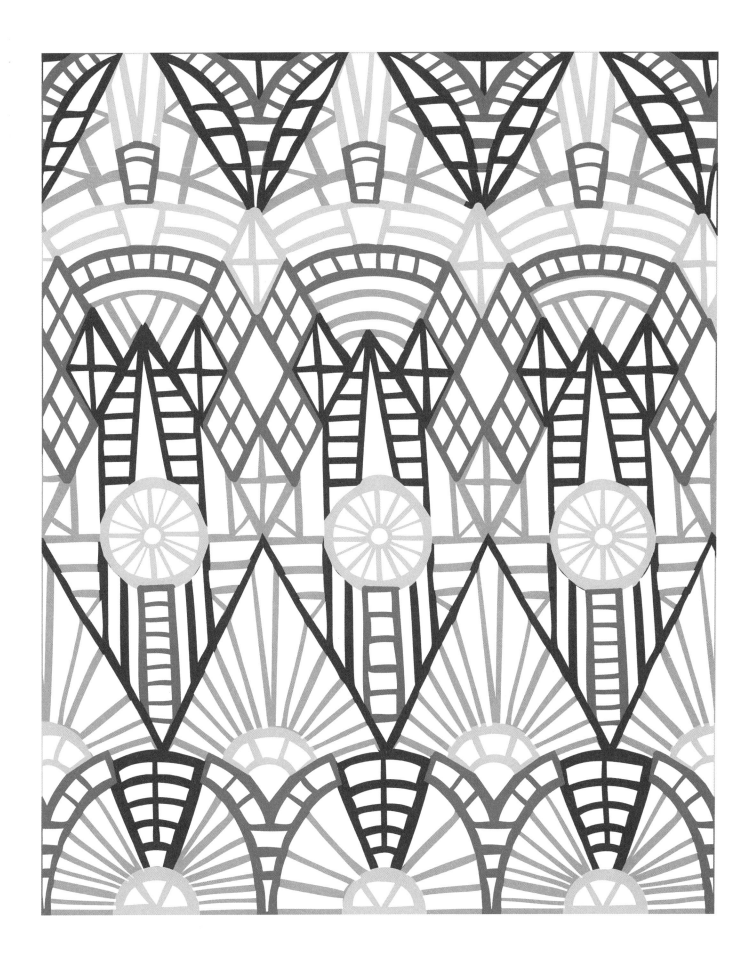

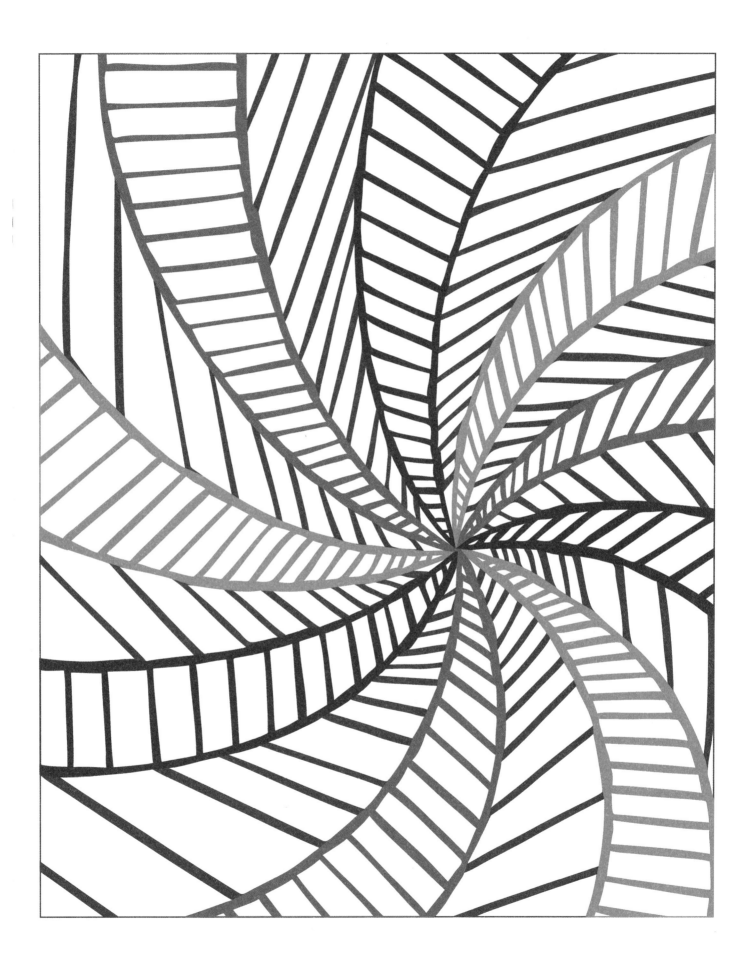

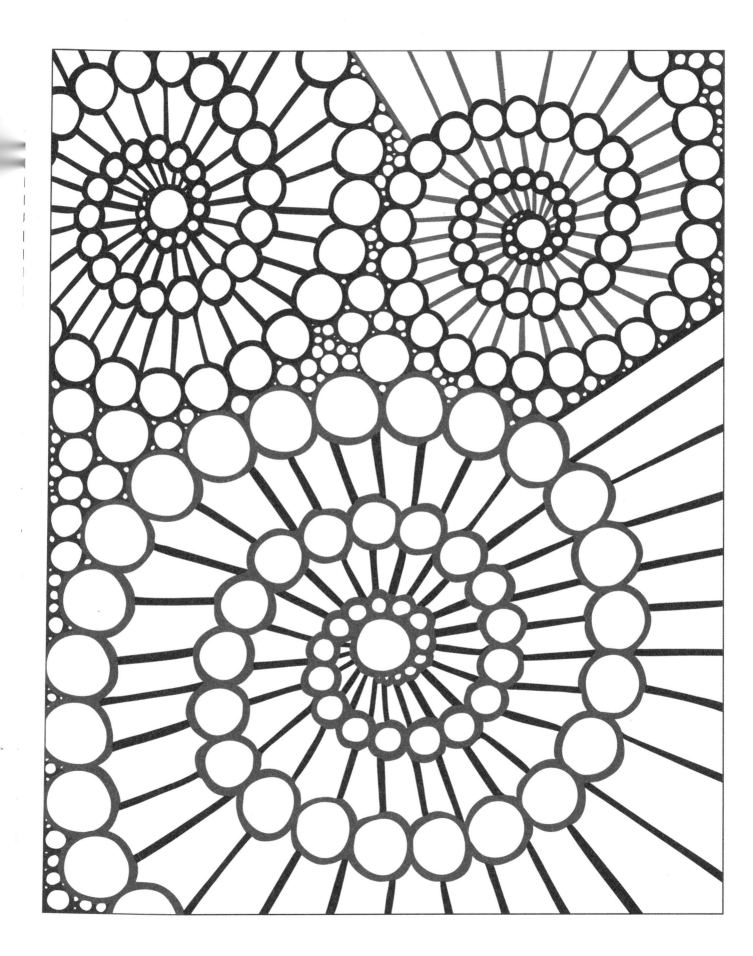